PHOTOGRAPHER'S AMERICA

Austin, Texas

Music City, New Money, Lost Dreams

Edgar T. Mosley

AMERICA
THROUGH
TIME

America Through Time
Fonthill Media LLC
www.through-time.com

First published 2025

Copyright © Edgar T. Mosley 2025

ISBN 978-1-62545-155-2

All rights reserved. No part of this publication may be
reproduced, stored in a retrieval system or transmitted in any
form or by any means, electronic, mechanical, photocopying,
recording or otherwise, without prior permission in writing from
Fonthill Media LLC

Typeset in 10pt on13pt Sabon
Printed and bound in England

Contents

Acknowledgments · 4

Introduction · 5

1 Welcome to Texas Y'all: Austin, Texas · 7

2 The I-35 East Divide: The East Side · 24

3 South Congress: The Boutique Side of Town · 39

4 Graffiti, Landmarks, and Art: City of Creatives · 53

5 The Music City · 68

6 The New Money · 74

7 Broken Dreams · 88

Final Thoughts · 94

Bibliography · 95

About the Author · 96

Acknowledgments

You may have heard the same story: my dad had a camera and that's how I got started in photography. Well, that is my story, too! For as long as I can remember, my dad was the one with that "old camera" at all the family events. I can still clearly see him with the camera in hand, bringing it up to his face and clicking away. When I found his camera on one of the tables, I messed with the settings, wound the film, rewound the lever, and clicked away.

I remember looking through the view finder and thinking: "This thing is broken, everything is blurry!" As we all get older, the thing called "life" starts to get in the way. As a young man, all the "cool" kids didn't toy around with their dad's camera; we just hung out on the streets and played football while putting dents in people's cars and spent hours playing videogames at the arcades. I would catch myself looking at a scene in my mind, trying to create a picture. My father did not know it at the time, but the thoughts and images that I have always had about his old camera reignited my love for photography. Now it has become my passion. I have evolved into my dad but in a new setting. Street photography is what I love, and I have my dad and his "old camera" to thank. I would also like to thank my wife, Nora, for not hassling me too much every time I came home with a different camera and went in-depth about sensor size, weight, megapixels, and shutter count. She would just roll her eyes and say, "Nice." Also, to my kids for the "not again" looks I get when I snap a picture of them engaged in the exciting task of homework, washing dishes, and watching television in their pajamas. Let's not forget their least favorite: the perfectly timed shot of them stuffing their faces with food.

Another thank you to the camera companies I have spent on buying, selling, and rebuying their gear: Sony, Canon, Olympus, and Fuji. They are truly the gift that keeps on giving. I must admit, in the early days I had G.A.S. (Gear Acquisition Syndrome) that was bad, but thankfully, I am kind of over it. Trust me, there are photographers around the world who have caught this at least once! I have pretty much settled on the Sony A7 Series of cameras; their autofocus capability and handling have won me over. Finally, a big shout out to my photography buddy, Daniel Plasencia (www. dplasenciaphotography.com), for excellent headshots, and my cousin, Charles Ratliff (may he rest in peace [Ratcheese88]) for our stomach hurting laughter together! Most importantly, thank you to Jay Slater and the entire creative team at Fonthill Media for this exceptional opportunity!

Introduction

The thing about photography is that if you have the creative itch to get into this field, the bar for entry is very low. You don't need the latest high-tech camera or to spend a ton of money to get your ideas out into the world. Just pull out the cell phone in your pocket and start making art. I have traveled around the world and interacted with different cultures and made friends, and the experience has always been amazing. I always tell people I meet that if you get the chance to travel out of the country, do it!

Looking at the world through the viewfinder of a camera really changes how things "look." When I arrive in downtown Austin, my view consists of the ten feet in front of me. If you ask anyone who has visited or lives in this city about intriguing places, with a smile on their face, most people will just start rattling off about the things to do, what you can see, and the places you can eat at. As for me and my camera, I get into my creative zone looking at people, objects wrapped in a unique position, and scenes with a sprinkle of light for that split second "click."

Austin is one of the fastest growing cities in the U.S. and the amount of people moving here monthly blows my mind! Everywhere you look, you can see the city streets and the skyline continuously evolving. The different cultures, art, attitude, and friendly faces you see walking around are just a few reasons why I love capturing this place. The following chapters in this book represent how I see this creative city and the people in it. This is not just on a computer screen, but through a viewfinder—MY viewfinder. I want to say "thank you" for coming along for the ride. Whatever medium you prefer to create with, get up, get out there, and go tell an amazing story.

1
Welcome to Texas Y'all

Austin, Texas

I have been in and out of the city of Austin, Texas, since the early 1990s. As a young soldier stationed at Ft. Hood, heading to downtown Austin on a Saturday night was the thing to do. I was amazed by the bright lights, live music, and people hanging out on the streets, and the general vibe of the city. Austin has always had the reputation for good food and music; it is the blood that runs through the city's veins and the heart of Texas.

Without the assortment of good music, it would just be another ordinary major U.S. city. Back then, Austin was kind of a sleepy town, compared to the bustling metropolis it has become. Of course, the city has always hosted music festivals going back to the seventies, eighties, and nineties—but nothing can compare to the massive music gatherings that are held throughout the city today.

Festivals held all over the city draw in musical talent that originated here locally, as well as musical talent from all over the world. Nearly a half-million people gather in the city yearly to attend the various musical events. The local hotels and house rentals are usually booked several months in advance. So, if you want a place to stay, and to not sleep in your car, the earlier you reserve a place, the better.

City traffic on the days when there is a huge music festival turns the city streets and IH-35 into, essentially, a bumper-to-bumper parking lot. It's kind of ironic to see a long line of cars sitting at a red light that has gone through several cycles, and watch dozens of scooters, weaving in and out of traffic, like a two-wheeled ballet. From its humble original gathering of musical hippies with Willie Nelson to the mega musical events such as SXSW, Austin City Limits Music Festival, Levitation, and Pecan Street Festival, you are surely to find something to your liking. So, grab a ticket, put on your sunglasses and comfortable walking shoes, and let the musical tunes lead the way. Austin isn't just called the "The Music Capital of the World" for nothing.

The following pictures are just a small representation of the music venues located throughout the city; it would take you months to visit all the locations. Even as certain music venues may come and go through the years, that foot tapping, head nodding, and fist shaking music always remains the heart of the city.

Austin, Texas

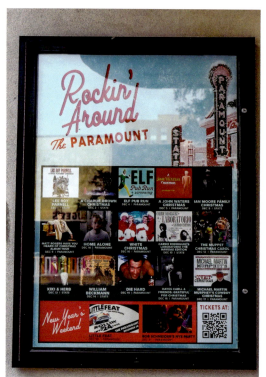

Left: Christmas Movies

Below: Cityscape Views

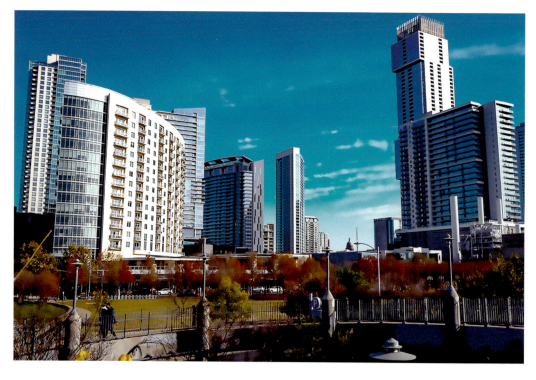

Welcome to Texas Y'all: Austin, Texas

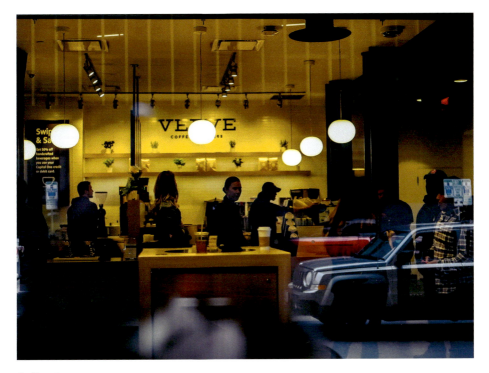

Coffee Lovers

Coming Soon

Austin, Texas

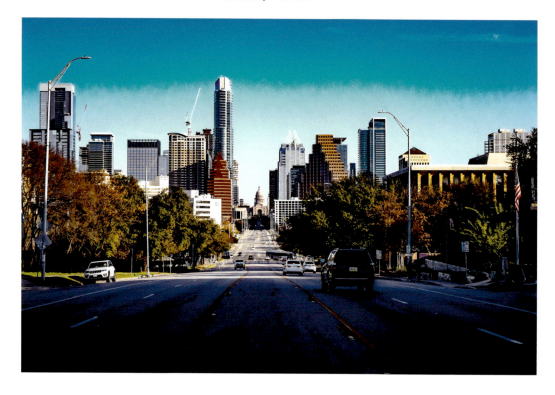

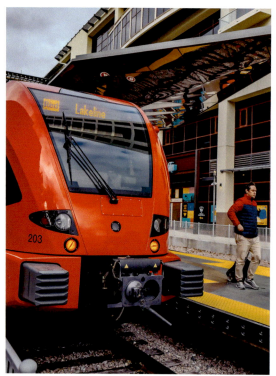

Above: Excellent City Views

Left: Get Off the Red

Welcome to Texas Y'all: Austin, Texas

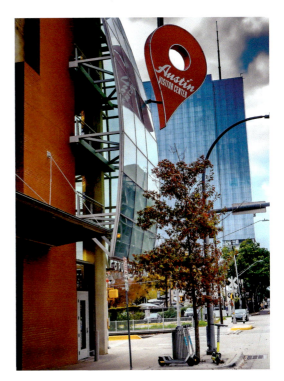

Get Your Maps Here

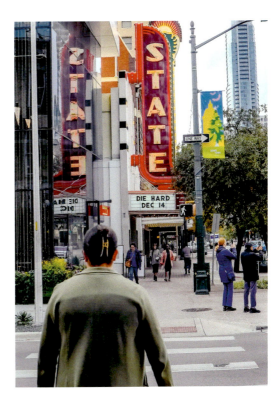

Showtimes

Austin, Texas

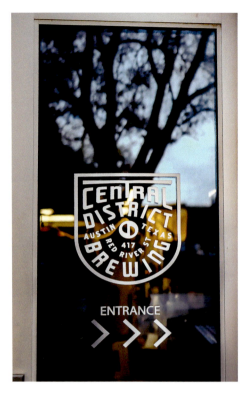

Good Local Beer

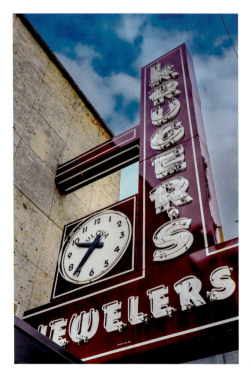

Hometown Jewelers

12

Welcome to Texas Y'all: Austin, Texas

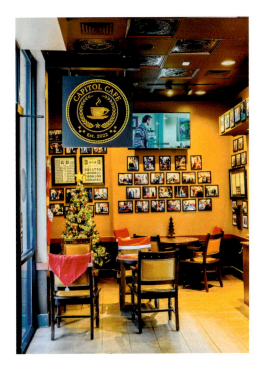

Right: Hot and Fresh

Below: In the Zone

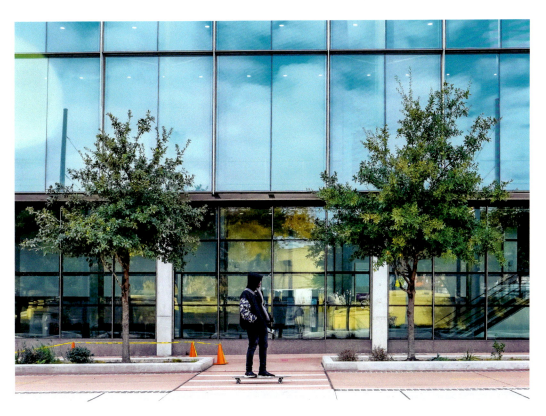

Austin, Texas

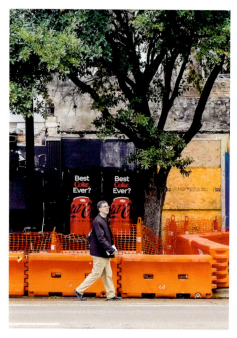

Left: Is It the Best?

Below: Passing By

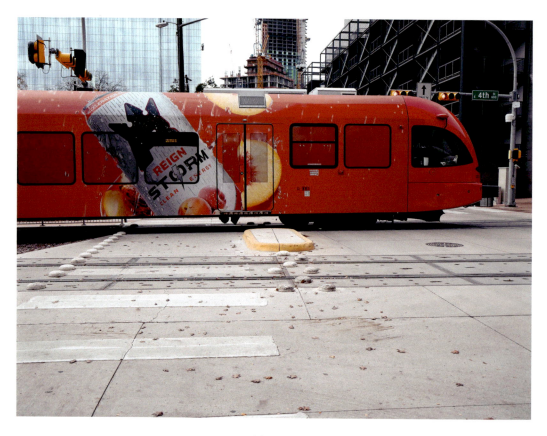

Welcome to Texas Y'all: Austin, Texas

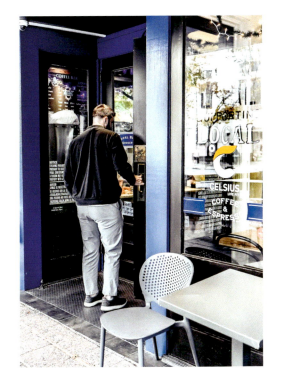

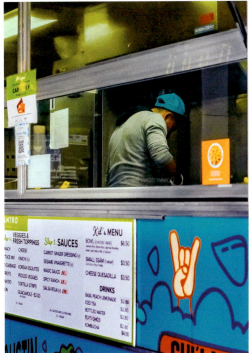

Above left: Keep It Local

Above right: Making Breakfast

Right: Morning Coffee Run

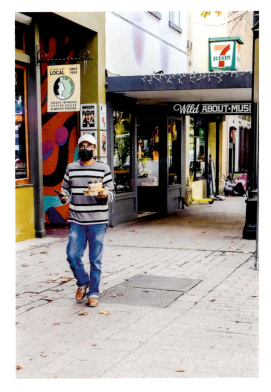

Austin, Texas

New in Town

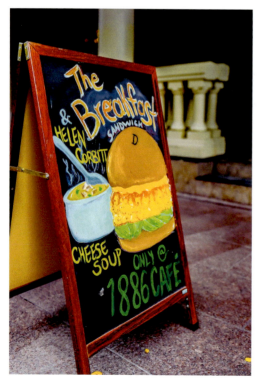

Really Good Breakfast

Welcome to Texas Y'all: Austin, Texas

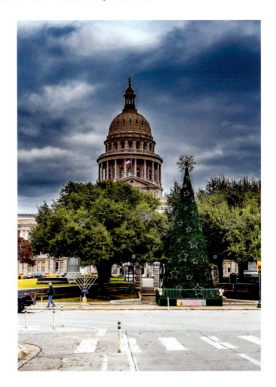

Right: Texas-Sized Christmas

Below: The ATX Metro

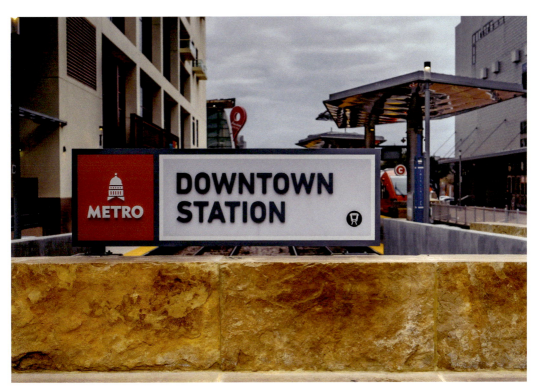

17

Austin, Texas

Left: The Best Way Around Town

Below: The Butterfly Bridge

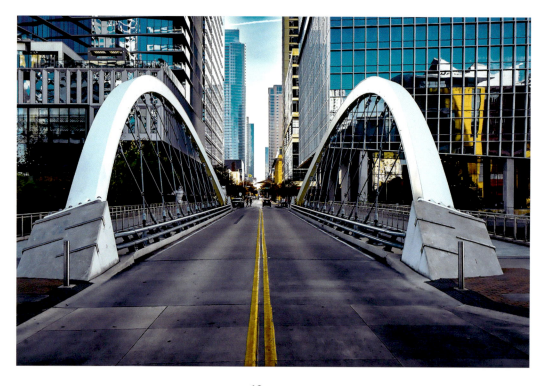

Welcome to Texas Y'all: Austin, Texas

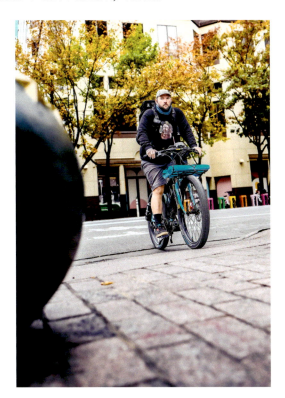

Right: The Commuter

Below: The Morning Prep

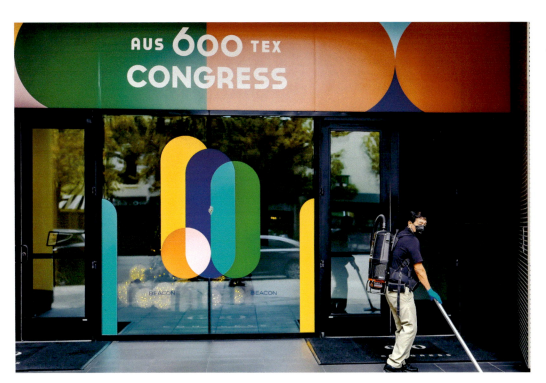

Austin, Texas

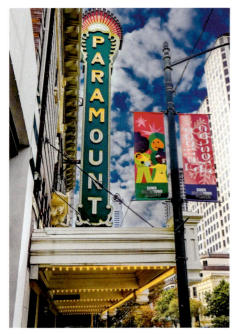

Left: The Paramount Theater

Below: The Punch Bowl

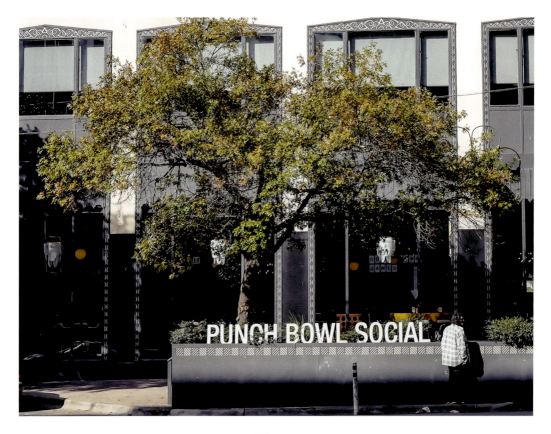

Welcome to Texas Y'all: Austin, Texas

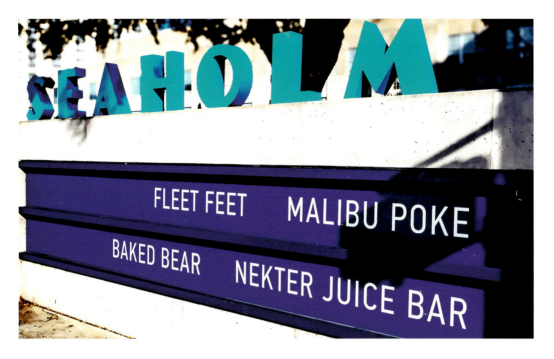

Above: The Seaholm District

Right: They Just Keep Coming

Austin, Texas

Where is Santa?

Yeah, Come and Take It!

Welcome to Texas Y'all: Austin, Texas

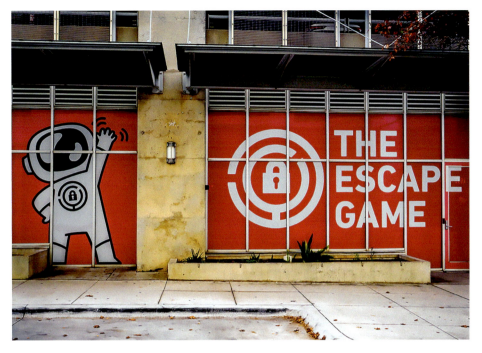

You Must Think in This Game

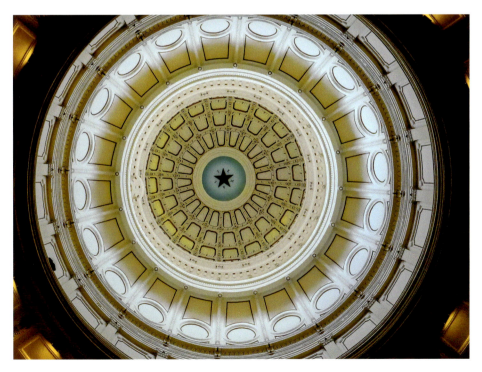

Looking Up at Texas

2
The I-35 East Divide

The East Side

Going back as far as I can remember, there are two different personalities of people that live on the East and West Sides of the city. The West Side of Austin has always been known as the "modern" side of the city, with its high-end homes, new condos, bars, small retail shops, and the vibe of a major downtown city. The East Side has been stuck in a kind of developmental time warp, with its old-school bars, the "grind" mentally, and old fixer-upper houses from the early 1950s through the 1970s. Until around the mid-2000s, when you went into the East Side of town, the differences were apparent between the two sides of this great city.

The East Side of Austin has always had its own energetic vibe; once you stepped into it and embraced its creative arms, you were okay. After you burn those calories from exploring the poetic nature of the East Side, it will be time to grab some really good food. Crossing over the IH-35 bridge, you will find several awesome places on the East Side to stop and satisfy your hunger.

It doesn't matter what you are in the mood for—this side of the city will have all your food desires covered. Trust me, you will have a great selection to choose from: Uptown Sports Club, VIA 313, Fukumoto, and Cisco's Restaurant has great Mexican food. Also, a quick tip if you want some old fashion school BBQ: make sure you stop by Sam's BBQ. Trust me when I say get a to-go plate for later.

The East Side of Austin is also full of historical jewels located around the city, such as the Texas State Cemetery, Victory Grill, and Huston-Tillotson University, just to name a few. It was around the mid-2000s that the face of the East Side and the state itself started to have a drastic change in the number of people arriving. No longer was the population only the offspring of those born and raised in Texas; New Yorkers, Californians, and Oregonians had started to show up. The conclusive regentrification process of the historic East Side had officially begun. The small family homes the once populated this side of town were now giving way to new luxury homes springing up all over the city's East Side.

The old story of the East Side is slowly fading away, and in some ways, that grind attitude is going with it. With the out-of-towners scooping up available property and hundreds of people flooding the city, change is here. The lifelong residents that have

The I-35 East Divide: The East Side

resided here their whole lives are now being shuffled along because of high property taxes. The semi-quiet neighborhoods are now overrun with joggers, jackhammers, cement trucks, and dog walkers. The city council preaches about affordable housing in the city, but those who have lived here their entire lives must keep moving eastward.

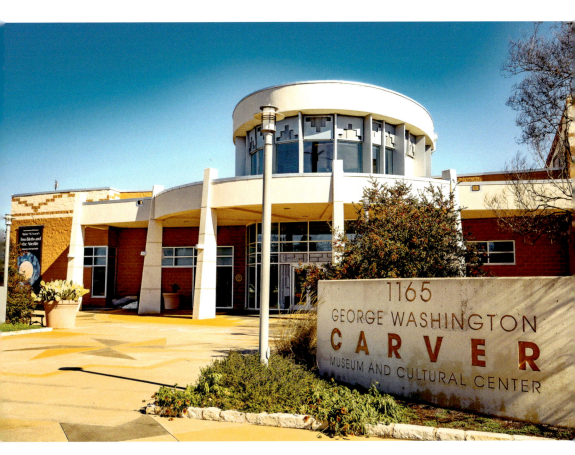

Carver Museum

Austin, Texas

Changing East Side

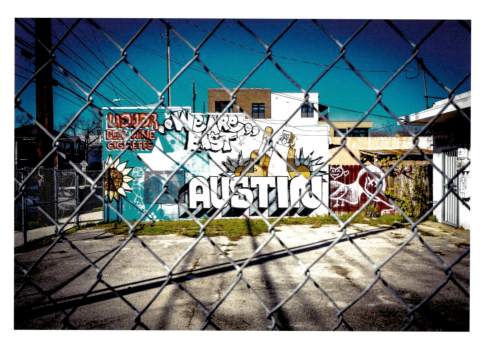

We Are East!

The I-35 East Divide: The East Side

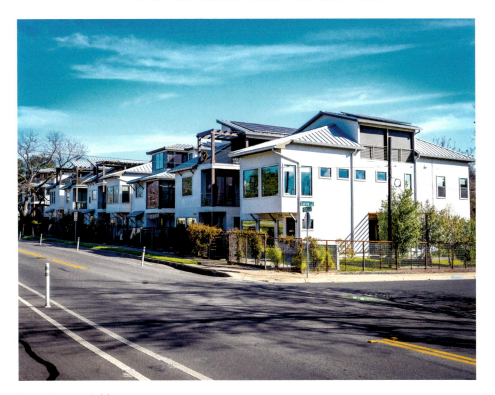

Your New Neighbors

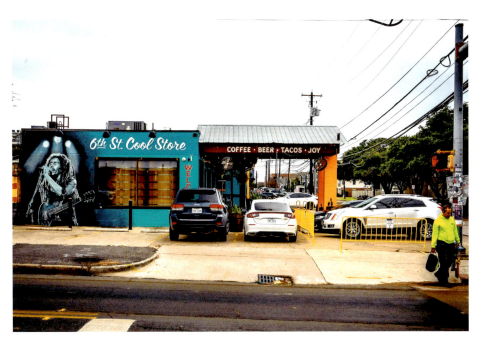

6th Street Store

Austin, Texas

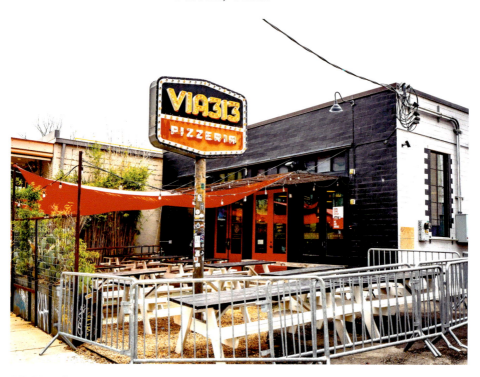

313 Pizzeria

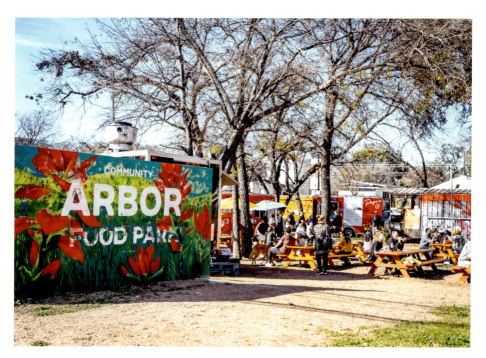

Arbor Food Park

The I-35 East Divide: The East Side

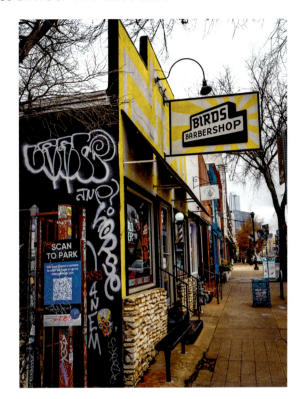

Right: Birds Barbershop

Below: Cisco's

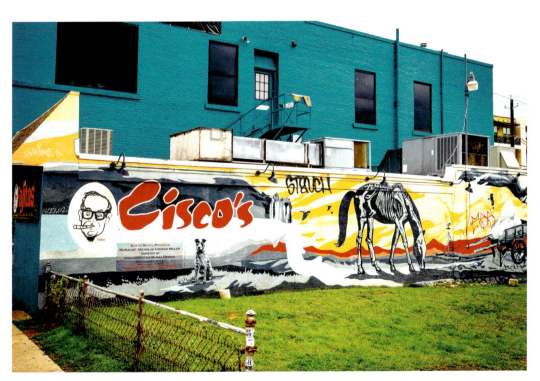

Austin, Texas

East Austin Pride

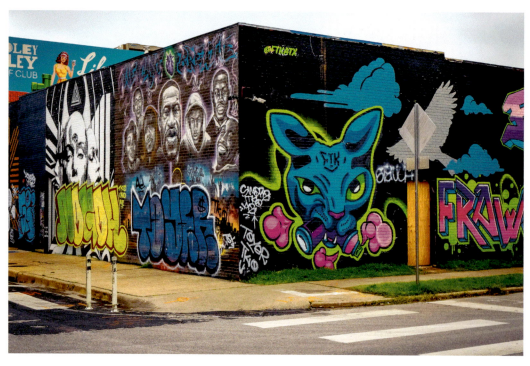

East Side Murals

The I-35 East Divide: The East Side

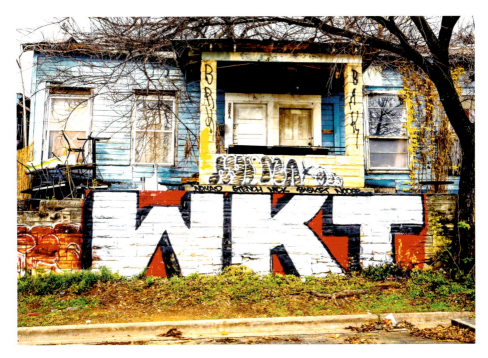

Got Your Attention

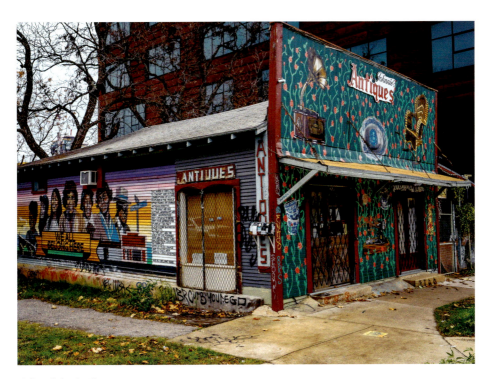

Johnnie's Antiques

Austin, Texas

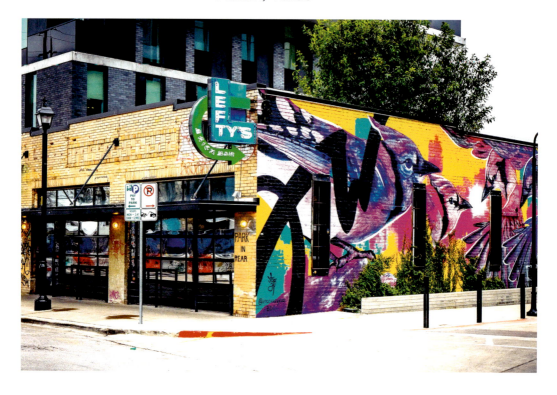

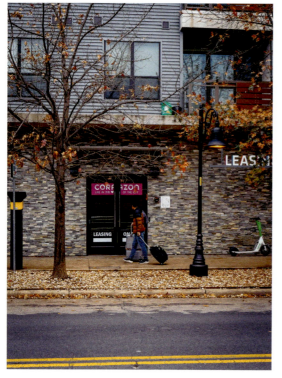

Above: Lefty's

Left: Looking For a Place to Stay

The I-35 East Divide: The East Side

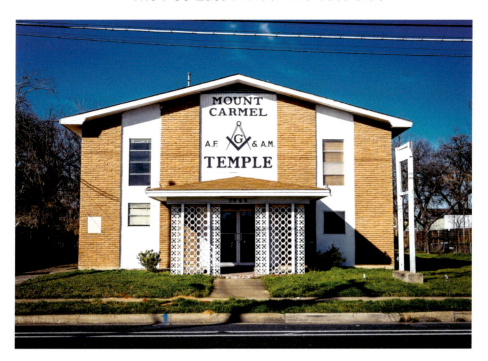

Mount Carmel

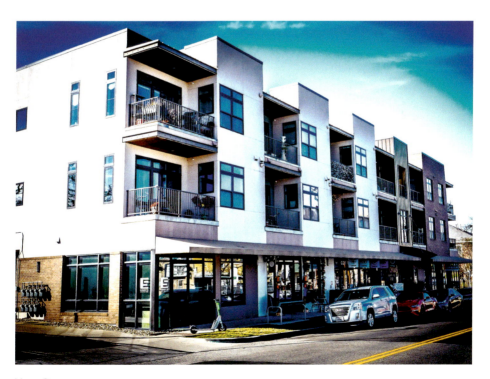

New Spaces

Austin, Texas

Left: No Longer

Below: Pedicab Shop

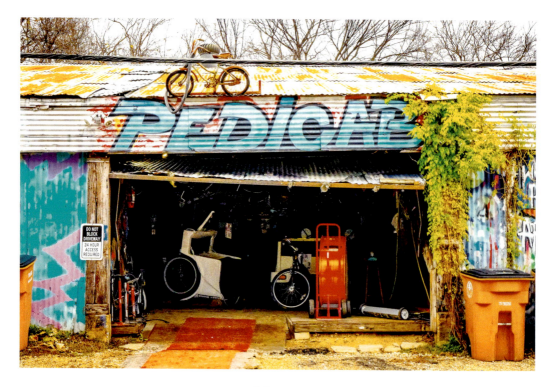

34

The I-35 East Divide: The East Side

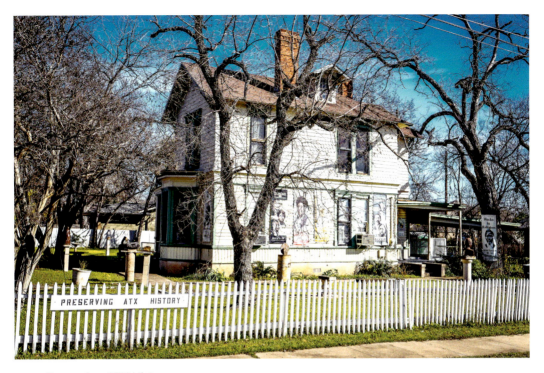

Preserving ATX History

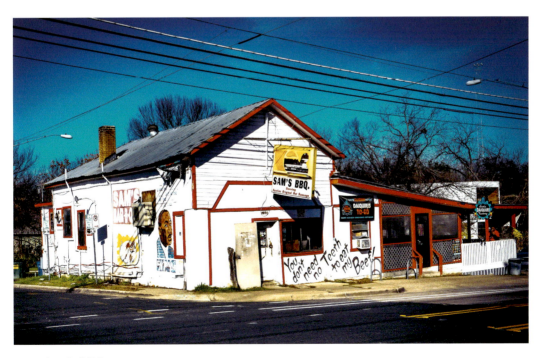

Sam's BBQ

Austin, Texas

Left: The Legend

Below: The Low Down

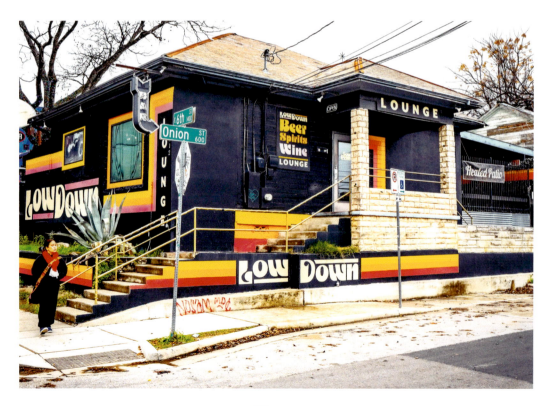

The I-35 East Divide: The East Side

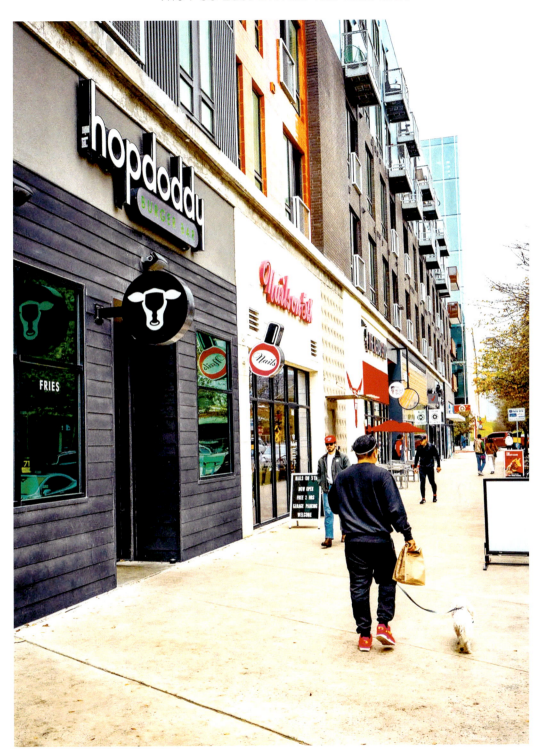

The New Residents

Austin, Texas

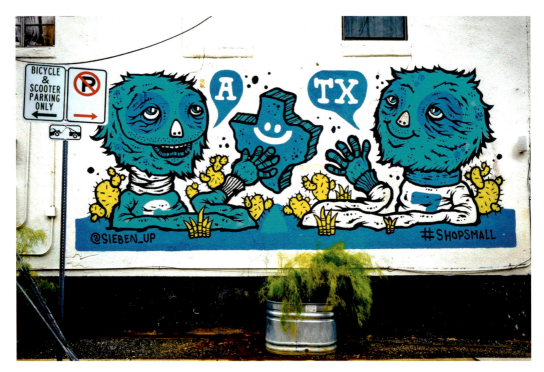

Shop Small

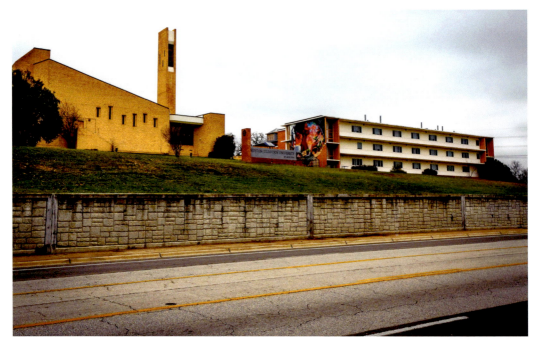

Houston Tillotson University

3

South Congress

The Boutique Side of Town

While downtown Austin is known as the hub and the heart of the city, if you cross south over the Congress Bridge, there is yet another city within a city, SoCo. It is located along on South Congress Ave., just over Lady Bird Lake (named after First Lady of the United States, Lady Bird Johnson). During the late 1990s, South Congress was a tough area to be in, and you didn't want to hang around the streets at night. Well, the times have changed! Make sure your checkbook and credit cards are ready, because you will need them when you arrive here. Like the East Side of town, this group of Austinites are proud of their home turf. South Congress is dotted with eclectic retailers and restaurants; it gives me the vibe of NYC. This area is known as SoCo by the locals, and a fashion sense is required.

The streets on this side of town are always bustling with heavy sidewalk traffic and buzzing store fronts. During the weekdays, the flow of people and traffic moves somewhat smoothly. On the weekends, this place turns into foot traffic madness. Usually around eight in the morning, you will see the streets start to come to life. You will literally drive in circles looking for a place to park, so, get there early or get ready for a long walk. Another unique feature of the SoCo district is that when you stand in the middle of Congress Ave, you will have a perfect bird's eye view of the Texas State Capitol; trust me, it's a cool site! That's because Congress Ave. slightly arches downward if you stand in the middle of the street, looking northward.

One of the most iconic stores that was located along SoCo was the famous Lucy in Disguise with Diamonds, a unique costume shop. It had been an Austin staple since 1984, offering a vast variety of costumes to satisfy your imagination. As the environment continued to change in Austin, this shop unfortunately had to close, but not to worry, new business continues to spring to life. When you visit South Congress, you must wear your walking shoes. The streets are lined with great places to eat and shop: South Congress Café, Magnolia Café, Jo's Coffee, Allen's Boots, Sunroom, and the famous Home Slice Pizza.

When you have finished filling your belly with some of that tasty SoCo food, it's time to spend a bit of your savings in the boutique shops that line both sides of the street, from the snazzy clothing shops like the Sunroom, to Unique Vintage clothing

Austin, Texas

and Feathers Boutique Vintage. While you are visiting, get yourself an excellent pair of cowboy boots at Allen's Boots. With the mixture of unique and fine craftmanship, your friends will be green with envy when they see you at the Monday morning team meeting.

While you sweat out your armpits in the Texas heat, enhancing your farmers tan, you will also be bombarded by skateboarders, dog walkers, motorcycles, and scooters. When crossing the street, have a "heads up" mentally, especially on the weekends. This is where you will finally use the "look left, right, and then left again" before you walk, or you will be asking for trouble. The sidewalks are packed with eager shoppers and sellers. Over the years, I have purchased several items from various local vendors, and the workmanship is outstanding. Their products are not cheap, but the craftsmanship will last long after you're gone.

South Congress: The Boutique Side of Town

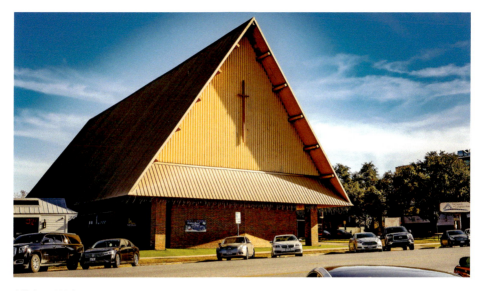

All Are Welcome

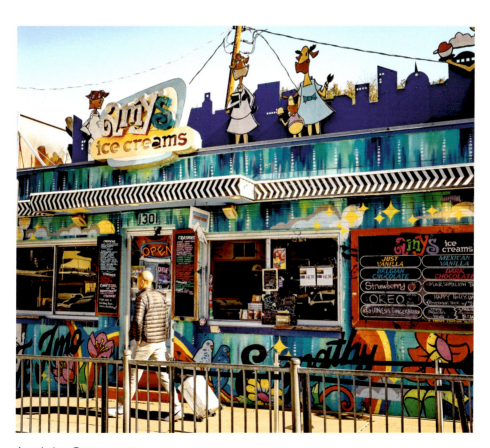

Amy's Ice Cream

Austin, Texas

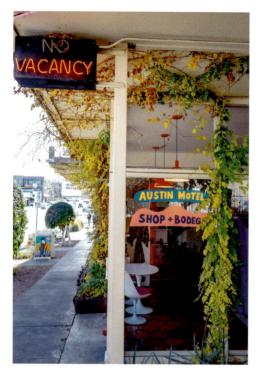

Austin Motel

Check-Out Time

South Congress: The Boutique Side of Town

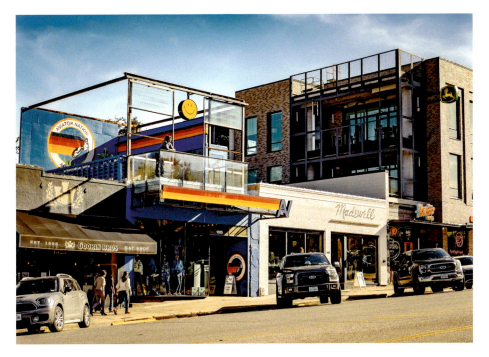

Enjoying the View

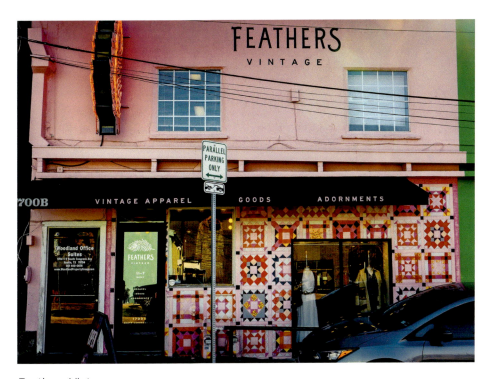

Feathers Vintage

Austin, Texas

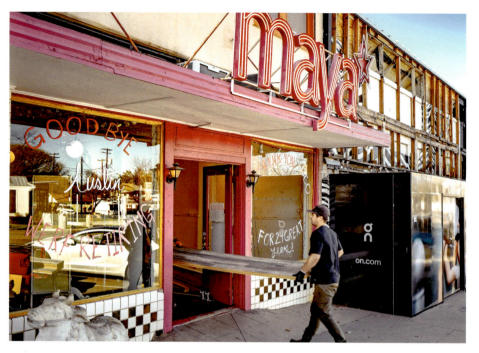

Goodbye Austin

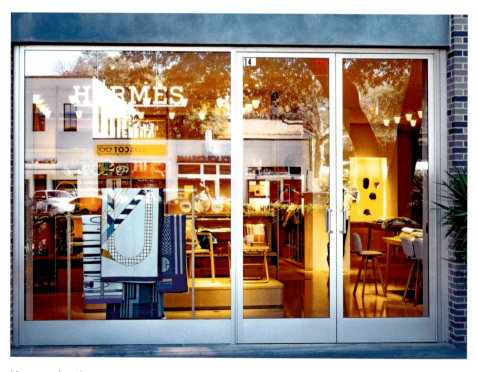

Hermes Austin

44

South Congress: The Boutique Side of Town

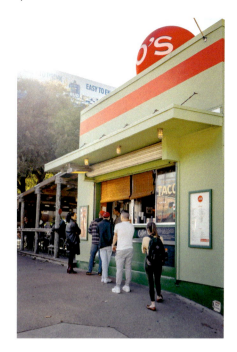

Right: Jo's

Below: King Ranch

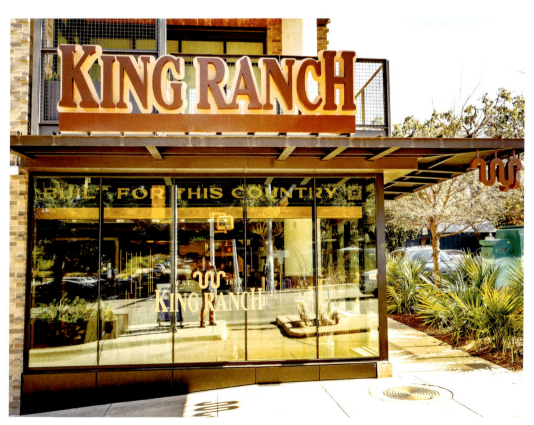

Austin, Texas

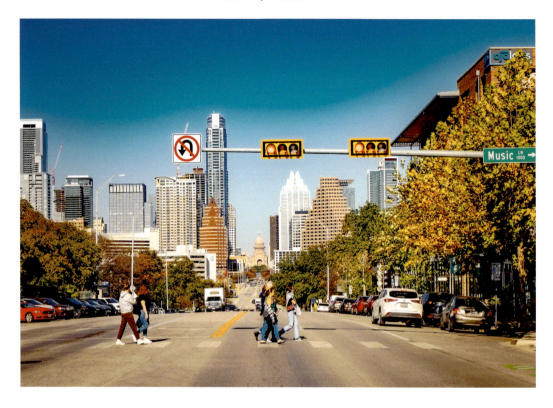

Above: Looking North

Left: Lululemon

South Congress: The Boutique Side of Town

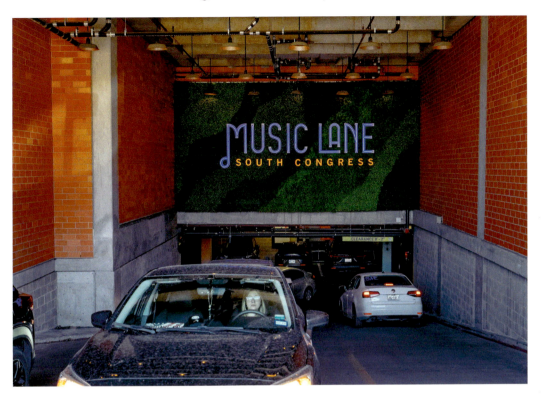

Above: Music Lane

Right: Pay to Play

Austin, Texas

Above left: Pick Up Here

Above right: South Congress Fashion

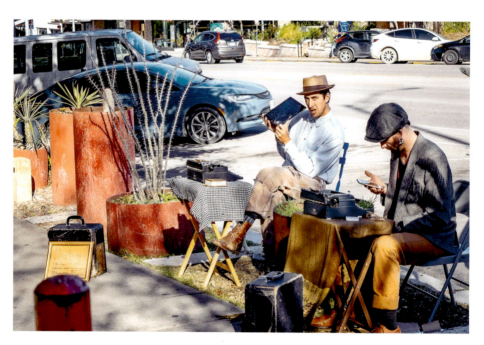

Tell Me a Story

South Congress: The Boutique Side of Town

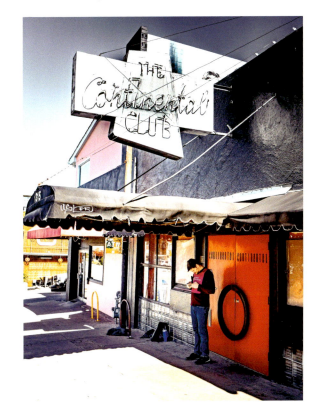

Right: The Continental Club

Below: The Cowboys

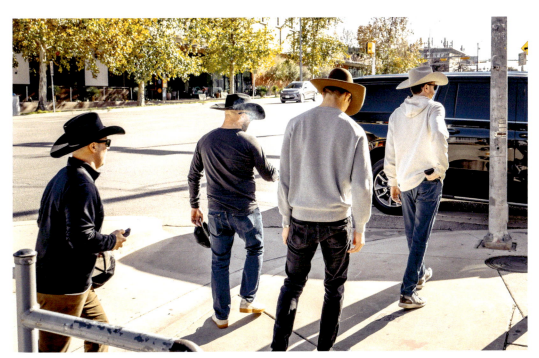

Austin, Texas

Left: The Dogs of SOCO

Below: The Evening Crowds

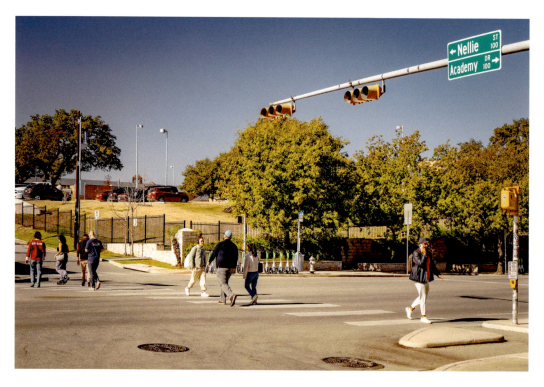

South Congress: The Boutique Side of Town

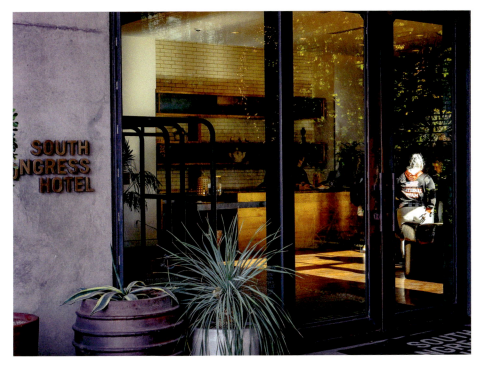

The South Congress Hotel

The Strip

Austin, Texas

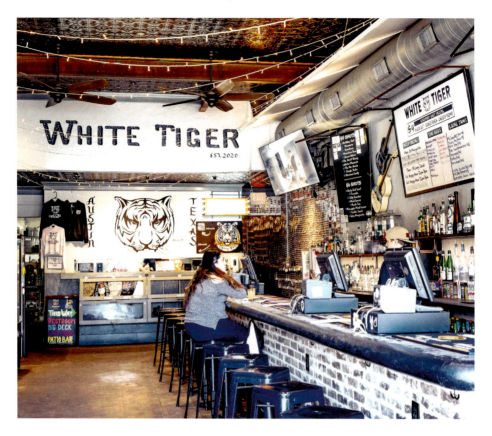

Above: The White Tiger

Left: You Belong Here

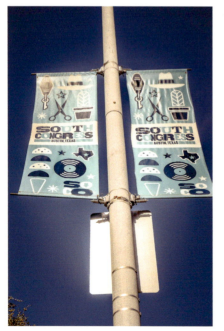

4

Graffiti, Landmarks, and Art

City of Creatives

Austin is known worldwide for its live music festivals. It is also home to many artists in different fields. As soon as you arrive, even at the airport, you will be greeted by art throughout the building. It is lined with sculptures, paintings, graphic designs, and so much more. If you dive into the city via the IH-35, while you sit in traffic for thirty minutes, you will see many incredible murals painted on the sides of houses, businesses, and abandoned buildings. Though many do not like it, I often get up close to the graffiti and admire the details in the brush strokes and colors and try to capture the individual's artistic mindset.

The city provides a sanctuary for creative artists from around the world to immerse themselves in their creative passions. Yes, there is a lot of graffiti that is painted throughout the city that conveys nothing at all, but there is a lot more that will make you want to stop and look closely at it. You must admire the purposeful intent of colors they select, almost as if they use a bag of spray bottles containing skittles.

Austin was the first city in the U.S. with an UNESCO "Creative City of Media Arts" designation. As you look around the city and even social media sites, you will notice the thousands of creative individuals that live here. I can't count the number of photographers looking to capture that "split second," videographers creating visual stories, and mural artists bringing once tattered walls to life. They say iron sharpens iron, and I say, "Cameras inspire my creativity." As I walk around the city, I am constantly pushing myself to step up my creative game.

Just the other day, I was strolling up and down Congress Ave. and ran into two other photographers. We all geeked out over our cameras, the settings, and our favorite places to shoot. I have talked to artists painting huge murals on the side of a building and often see other creatives in the "zone" of their work. There is a plethora of places here in Austin where you can go and experience some creative projects.

If you are into visiting museums or attending street art festivals, you are in the right place. The Pecan Street Festival was first held in 1978 and was a large gathering of

creative individuals. At this festival, you will be surrounded by hundreds of people. The event is held on 6th Street in downtown Austin. The festival is held twice a year in the months of May and September. You will find the streets full of people engaging with artists and admiring their crafts. I have attended this festival on several occasions. If you ever get the chance to attend, you should do so. The streets are filled with a variety of artists who offer all kinds of works and objects for purchase. Artists from all over the world bring their works to sell. From detailed glass works, leather goods, and beautiful paintings, this is a one-of-a-kind festival that is held in Austin.

Switching over to another type of art, the Blanton Museum of Art is a beautiful museum located at the University of Texas. This museum is truly heaven for all the art aficionados out there. It was founded in 1963 and houses a vast collection of short and long-term collections. It has a collection of more than 21,000 paintings and prints as well as a large American and Latin American art collection.

Another excellent museum is the wonderful George Washington Carver Museum and Cultural Center located on the East Side of Austin. The museum has its core exhibitions, and throughout the year, it has several rotating exhibitions. One of the most moving and powerful presentations here is the Freedom Plaza area that is home to the Juneteenth Memorial Sculpture Monument. These sculptures are a poignant reminder that echoes in American history. The intricate details of the sculptures are astonishing. Inside you will be inspired by the Families Gallery and L. C. Anderson High School Exhibit. This is a must-see museum when you arrive in the city.

The Contemporary Austin is another fine museum located in the heart of downtown Austin, a short distance from the Texas State Capitol. It hosts some excellent exhibits, and if you go on Thursdays, admission is free. They also have a Drop-In Tour Program with paid admission; it gives visitors the ability to discover in-depth information about the building itself. Another thing that is unique to The Contemporary Austin is that it has two locations. If you want to visit them both, clear your schedule—they are worth the visit. The second location is called The Contemporary Austin Laguna Gloria. This site is situated on fourteen acres overlooking Lake Austin. A couple years ago, I took my grandson to an art class at this location. He had a blast in the class, and I was amazed by the grounds; they are simply stunning! If you arrive in the summer months, a water bottle is a must. This location not only has stunning grounds but is home to an art school that teaches thousands of students yearly.

The Austin area also has some very impressive landmarks in its portfolio that will leave you amazed. Let's start with the majestic Texas State Capitol. This building is an architectural gem. It is also taller than the United States Capitol in Washington, D.C. When you walk up to it from either the south or north entrances, the view is jaw dropping. Bring a camera with a full battery, because you will be snapping away. The Capitol grounds are amazing and well maintained, and when you look up at the Capitol dome, the Goddess of Liberty will be looking down back at you. The statue on top of the dome is a replica that replaced the original in 1986.

The original Goddess of Liberty statue is located on display at the Bullock Museum. Once you get inside the Texas State Capitol, this is part two of the unique details of the building. When you walk to the center of the floor and look up at the dome, you will get lost in thought, admiring the details. Make sure you also go to the Extensions

and look at more history below ground and grab a bite of food in the cafeteria.

No matter where you look inside the Capitol, the marvels never end. The Pennybacker Bridge, also known as the "360 Bridge," was constructed in July of 1982. The bridge has a through-arch design, and the beautiful, rusted arches span across Lake Austin. The rusted look, made from weathering steel, gives the Pennybacker Bridge its distinct look. The bridge design is simply beautiful and as you drive across it, you will catch yourself eyeing the arches. But I must warn you, if you do this in peek morning or afternoon traffic, you will be making an insurance claim on your car. This area has a lot of heavy vehicular traffic.

The Austin area hosts several other notable landmarks that are well worth your time, such as the Stevie Ray Vaughan Statue, located at Auditorium Shores. This statue is an eye-catching tribute to a musical legend. He was an outstanding guitarist with a distinct set of vocals. He tragically died in a helicopter crash in 1990. Another historical location in Austin is the UT Tower's towering silhouette, a beacon on the campus grounds. The tower stands at 307 feet and is one of the university's most distinguishing features. This city resonates on street corners, buildings, and city landmarks that are full of rich history and creativity. When you arrive, be prepared to immerse yourself in the spirit of creativity that will surround you.

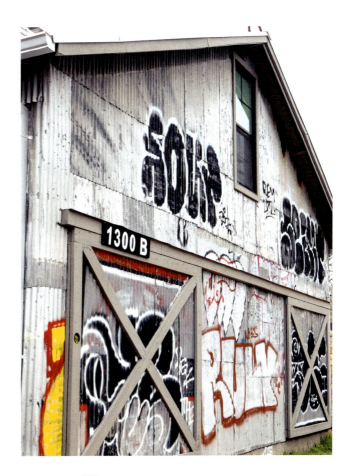

Added Character

Austin, Texas

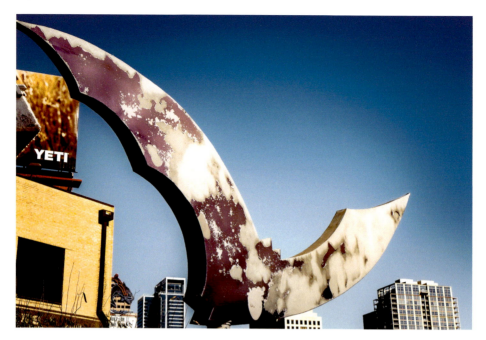

Bat Statue

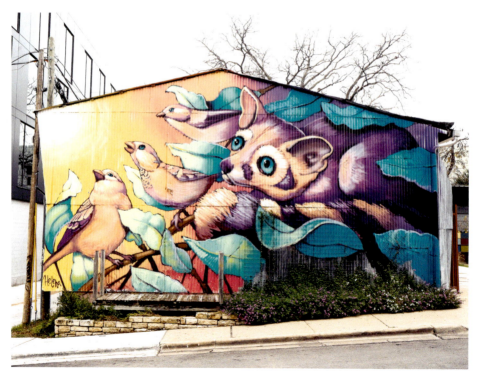

By Helena

Graffiti, Landmarks, and Art: City of Creatives

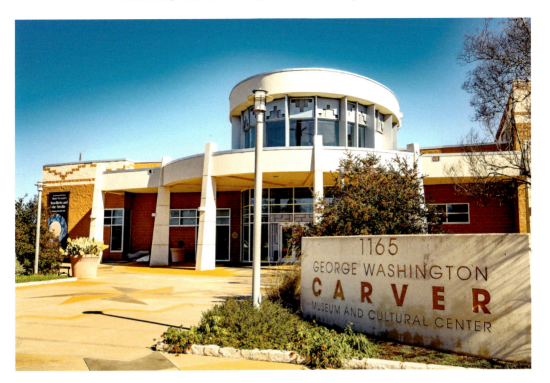

Above: Carver Museum

Right: City Art

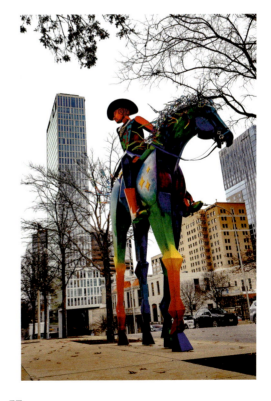

Austin, Texas

Colorful

Creative

Graffiti, Landmarks, and Art: City of Creatives

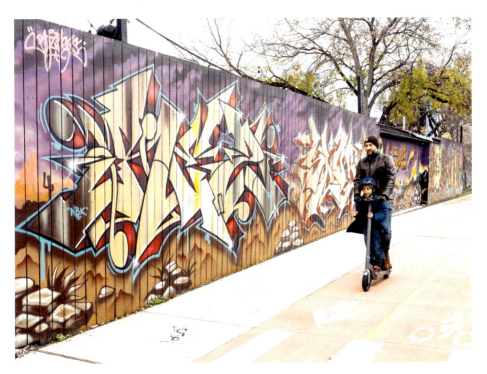

Father and Son

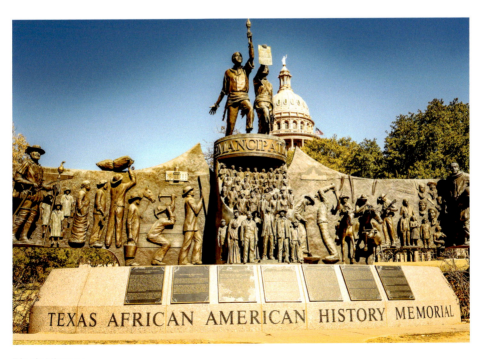

Black History

Austin, Texas

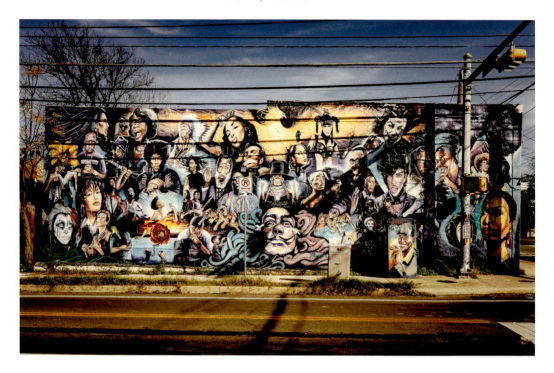

Above: East Side Mural Art

Left: Old Bakery and Emporium

Graffiti, Landmarks, and Art: City of Creatives

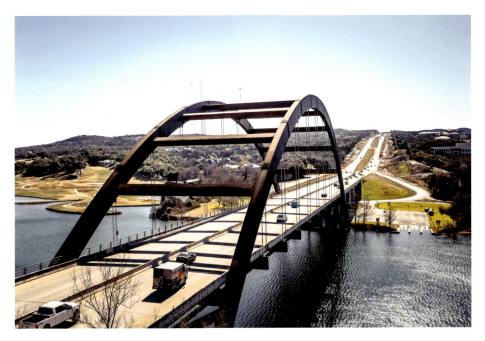

Pennybacker Bridge

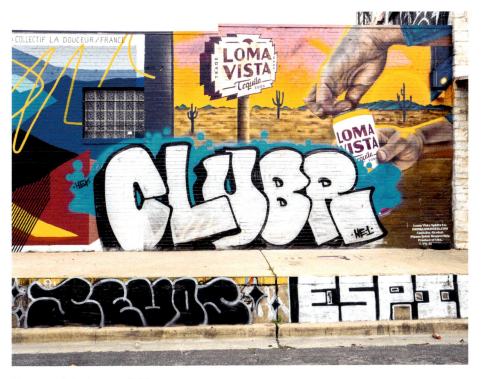

Please Drink Responsibility

Austin, Texas

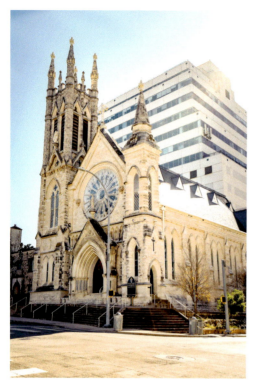

Left: Saint Mary's Cathedral

Below: Tejano

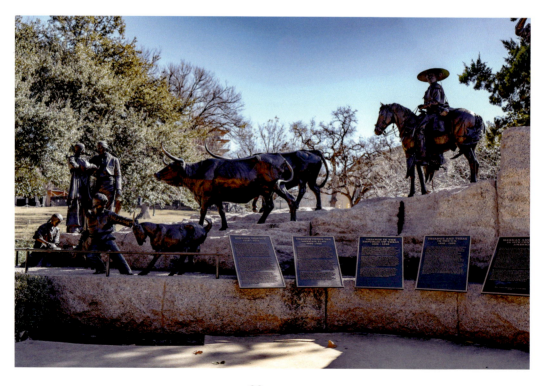

Graffiti, Landmarks, and Art: City of Creatives

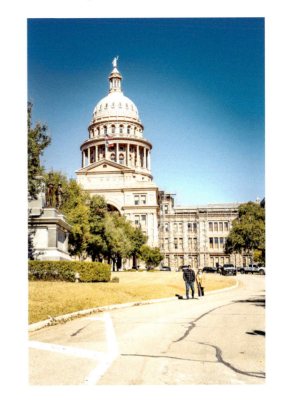

Right: Texas State Capitol

Below: Texas Toast

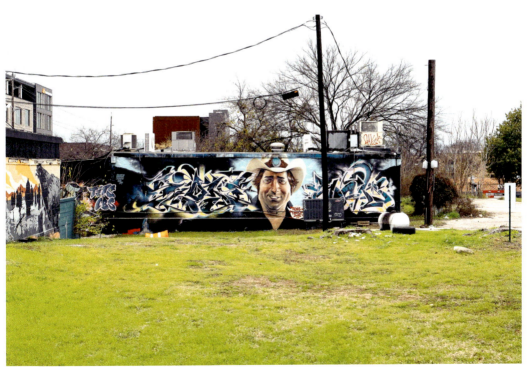

Austin, Texas

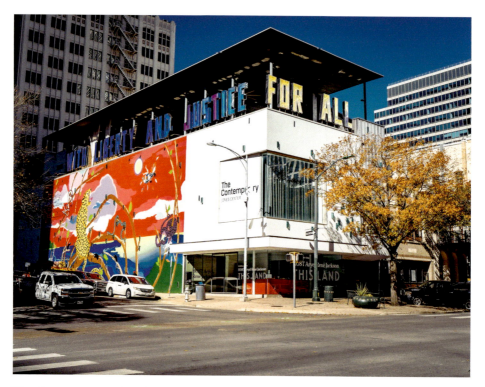

The Contemporary Austin

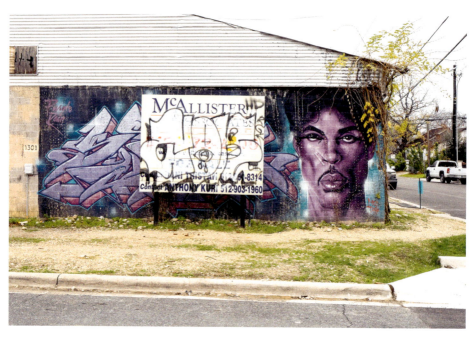

The Icon

Graffiti, Landmarks, and Art: City of Creatives

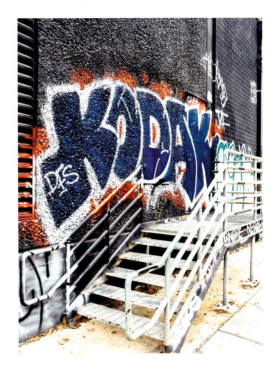

Right: The Staircase

Below: Through the Fence

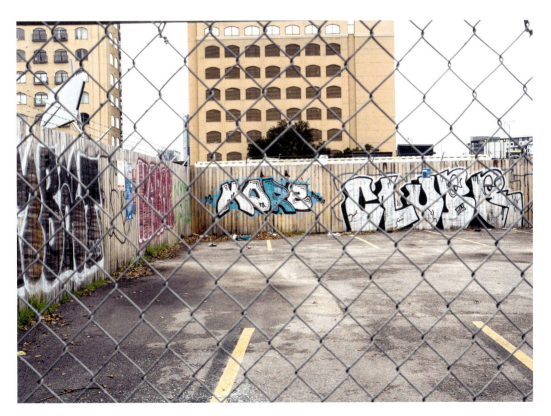

Austin, Texas

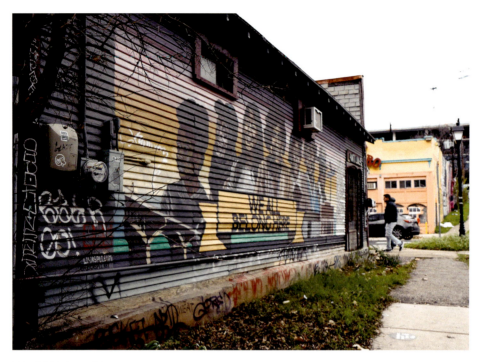

We All Belong Here

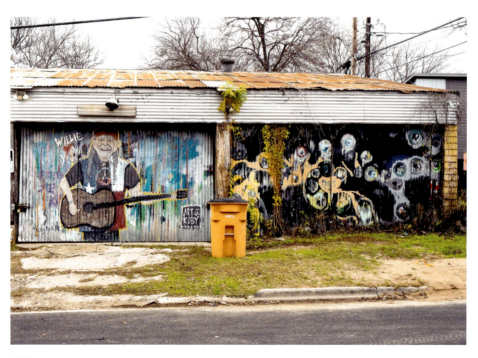

Willie

Graffiti, Landmarks, and Art: City of Creatives

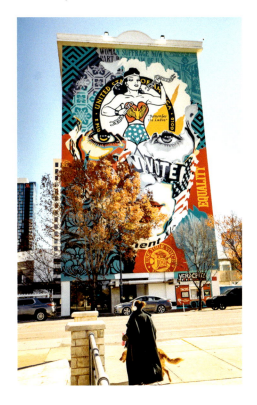

Women's Rights

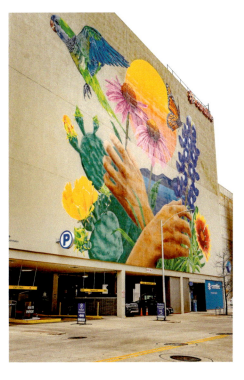

Beautiful Artwork

5

The Music City

Austin, Texas, is well known for many things, but at the top of that list is its designation as the "City of Music." Every year, there are thousands of red-eyed travelers arriving, eager concertgoers, packing the Austin airport. Weeks before the partygoers arrive, the city wraps light poles, shuts down streets, and puts up signs and placards. As South by Southwest (SXSW) approaches, I have been downtown on several occasions when the city starts to prep itself for the event, and you can feel the energy and anticipation in the air.

Like a gigantic ant colony, the city workers, music venues, hotels, and Peddie cab drivers are all working and moving in sync. I truly enjoy walking around, watching the entire process unfold. Some venues that have been dormant come back to life with new paint, speakers, and revamped soundstages. I often laugh to myself when I see all the new kids on the block, with their "music badges" swaying back and forth around their neck. The price of those badges is not cheap by any means; it's like having a paper gold necklace hanging around your neck.

A music festival like South by Southwest (SXSW), or as it is commonly referred to as "South By," draws in thousands of people from around the world, not including the thousands of artists who perform at the festival. The festival is unique in that not only does it include music, but also a film festival, and it has a technology aspect to it. The film festival itself showcases very promising up-and-coming talent and brings in some of Hollywood's famous actors. So, if you don't want to dance, grab a beer and enjoy the visual arts.

Not to be outdone or overlooked is the Austin City Limits Music Festival. This festival is held two weekends back-to-back. It's funny how in one weekend, Austin is transformed into a city of foot and scooter traffic that will have you thinking: "I thought I moved away from New York City?" If you are planning on attending this huge festival, step up your preplanning game early. The festival is held on multiple sound stages and encompasses hundreds of outstanding music venues. Over the years, there have been several legendary artists who have performed at this festival: Hozier, Foo Fighters, Tegan and Sara, The Mars Volta, and Shania Twain, just to name a few. It's easy to see how this festival sells out yearly. Your ears will guide you to the sound of music that is literally on almost every block. Also be mindful of the scooter speed demons whizzing up and down the street, and yes, even the sidewalks!

While music festivals such as SXSW and ACL take the spotlight, there are still

several other well-known festivals held in the area yearly. Fusebox, a grassroots event, offers a different experience and tackles important issues.

This next one is free, and if you have kids, this one is for you: Squirrel Fest. There are lots of activities for kids and even a free movie. Trust me, it doesn't matter what kind of music that you are into; here in Austin, with hundreds of musical festivals in the city, you will find yours here.

With all the great music diversity that comes out of Texas, this state has produced some great iconic legends. Here are just a few of those icons that hail from this state: George Strait, Selena Quintanilla, Stevie Ray Vaughan, Nelly, Barry White, Willie Nelson, Erykah Badu, Kelly Clarkson, Beyoncé, and ZZ Top. While this list of music icons is very impressive, we still have not even scratched the surface of the musical talent that this state has produced. The state's musical veins run deep and continue to deliver outstanding musical talent. So, the next time you plan to attend one of these music festivals in Austin and immerse yourself in great music, mark your calendars well in advance.

It does not matter if you are a fan of up-and-coming talent or the past and present chart-topping sensations, you will find the musical genre you are looking for in Austin. Let your ears guide you and your feet move you to the musical venue that will leave a smile on your face in the heart of Texas!

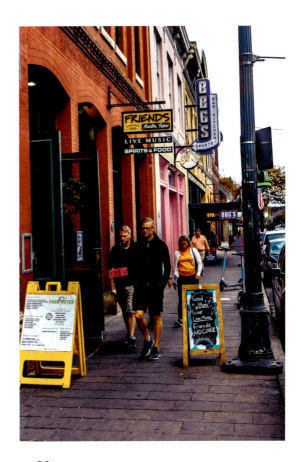

Live Music and Doughnuts

Austin, Texas

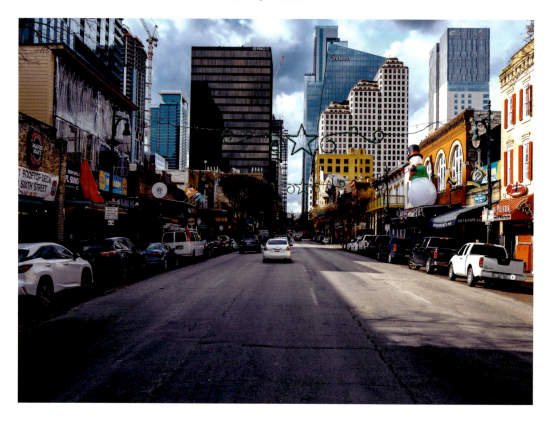

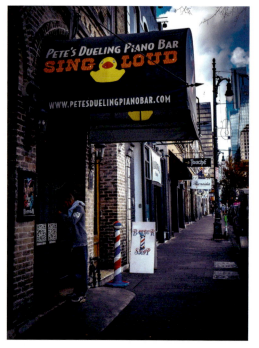

Above: Street View

Left: Sing Loud

The Music City

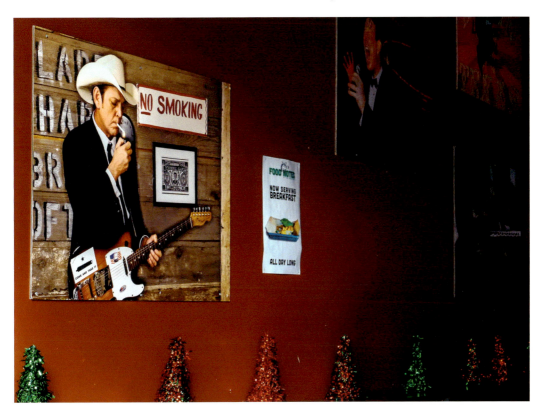

Above: Read the Sign

Right: Stairway to Heaven

Austin, Texas

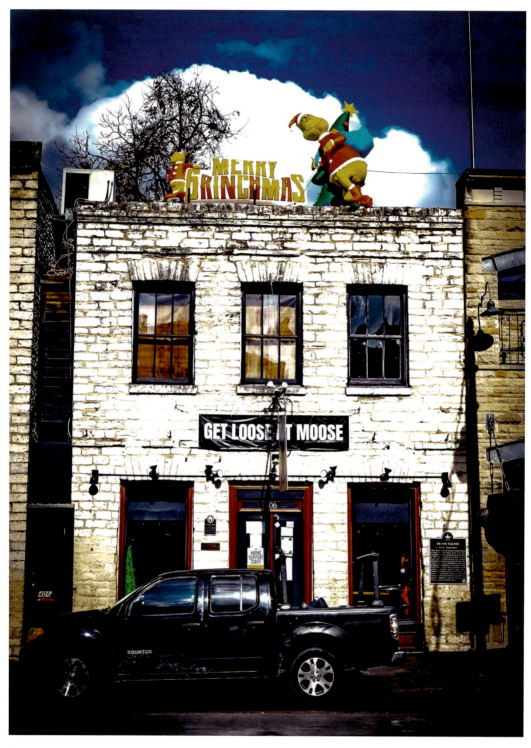

That Naughty Guy

The Music City

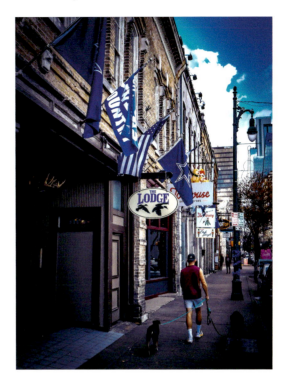

The Lodge on 6th

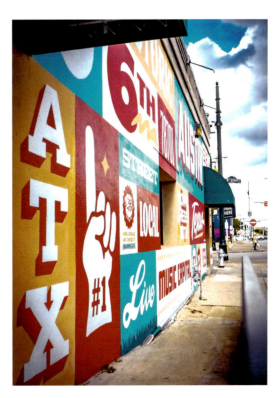

Welcome to the ATX

6

The New Money

Around ten years ago, Austin was a big city, but it did not have that big city vibe. New construction went up sporadically around the city, but it was not a big deal, and you would drive right past it, unnoticed, like you would a 7-11 corner store. Looking back at it now, those were the good old days. Now as you approach the city, the Austin skyline looks like the backdrop of a dystopian movie. Looking up, there are sky cranes every few city blocks.

In the past ten-plus years, the big tech companies have claimed Austin's college-educated population as their own. If you didn't know, Austin has its own Silicon hills that took root in the 1990s—an area in which all the well-known tech companies are based out of. This area came into development around the mid-1990s. With the influx of big tech companies moving into the city and a steady stream of people moving into the area monthly, they have brought in a wave of new money, redefining and reshaping the area.

With an army-size amount of people flooding the city, the cost of living has soared, leaving a sour taste in the mouth of lifelong residents. People are drawn to Austin, and to Texas in general, for its affordable lifestyle. Things such as nightlife in the city, the cost of buying a home, the vast amount of festivals, and the warm weather make living here a no-brainer. If there is an empty lot in the city, you can bet your Texas Two-Step, a condominium will be erected on that property!

As the city becomes flooded with new wealth and out-of-state license plates, change is only evolving faster. The coffee shops, electric car dealerships, high-end boutiques and high-priced jeans are now part of the everyday Austin landscape. But no place has undergone a drastic change in urban landscape like the East Side of the city. Over the years, I have noticed that established city residents must sell their homes and leave the city they once knew. With expansion and corporate giants relocating into the city, Austin is transforming into a modern-day mega metropolis. If you are relocating from another city to live here, your money will go a long way. If are on the flip side of this influx coin, make way—the wave is coming, and they have deep pockets!

The New Money

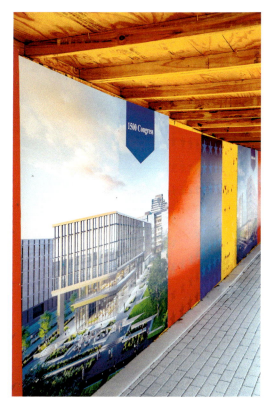

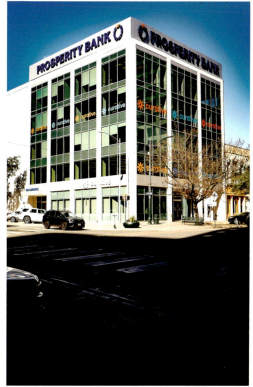

Above left: 1500 Congress

Above right: The Bankers

Right: Big Tech

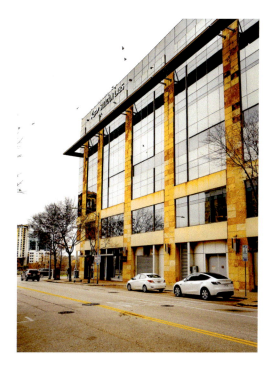

Austin, Texas

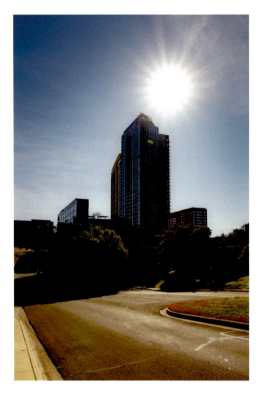

Left: Come Live Here

Below: Dean's Steakhouse

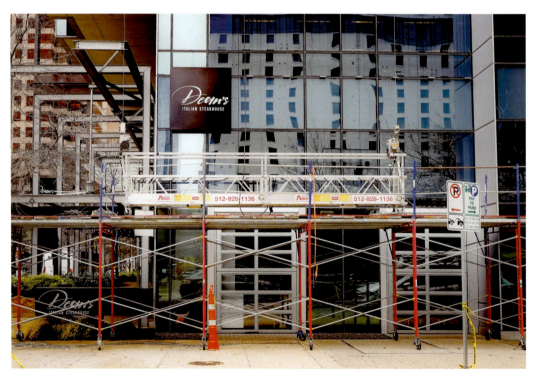

The New Money

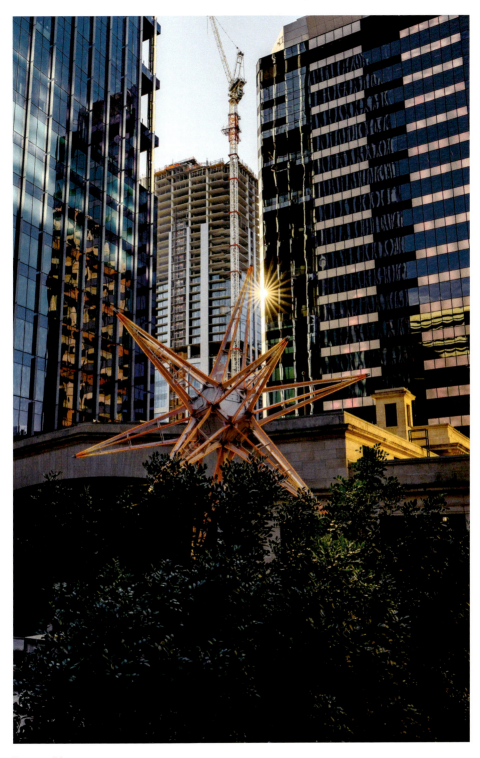

Dream Big

Austin, Texas

Left: Essential Workers

Below: Farm Fresh

The New Money

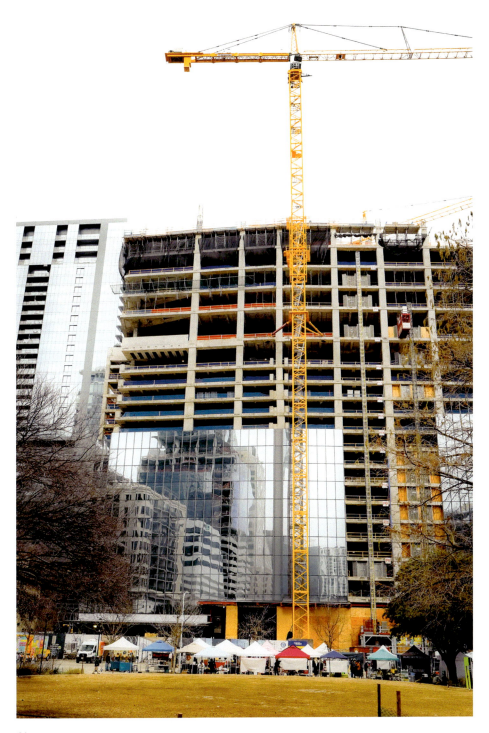

Giant

Gina's on Congress

The New Money

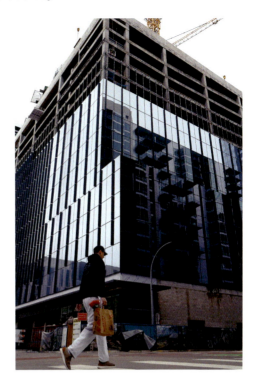

Right: Halfway Up

Below: Making Way

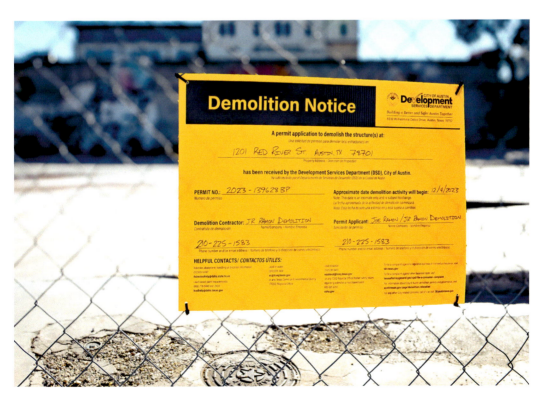

Austin, Texas

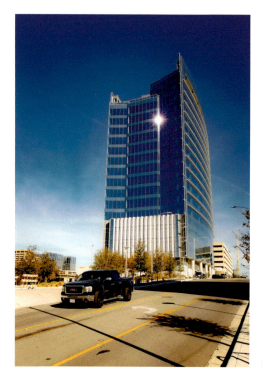

New in Town

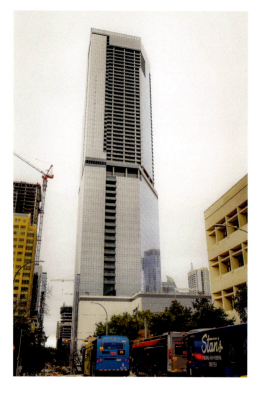

West Side friends

The New Money

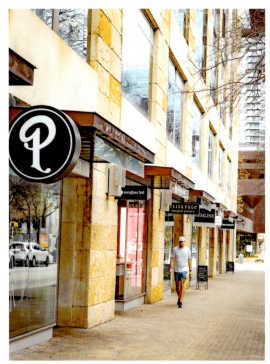

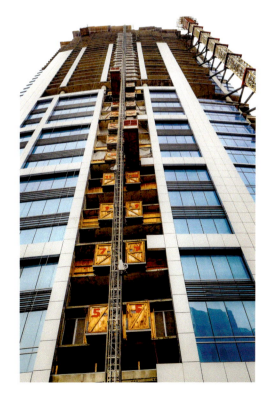

Above left: New Resident

Above right: The Shops

Right: Numbered Floors

Austin, Texas

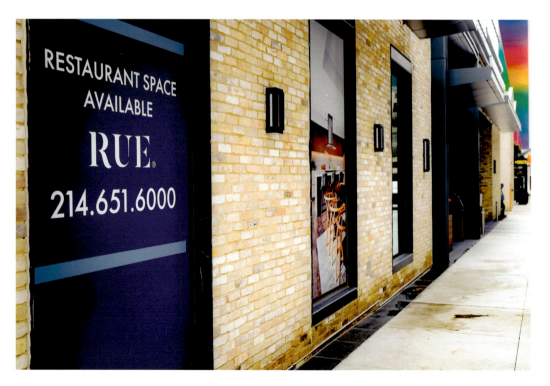

Left: Out-Of-Towner

Below: Space Available

The New Money

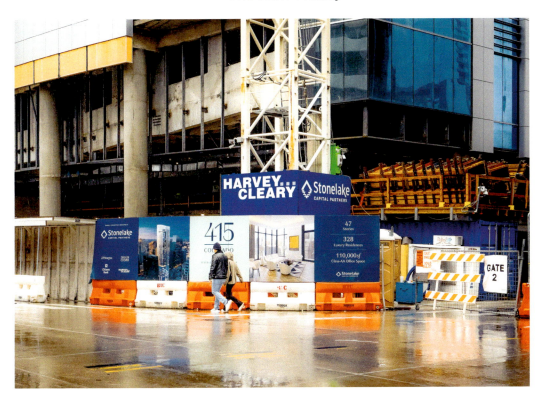

Above: The 415 Colorado

Right: The Hanover

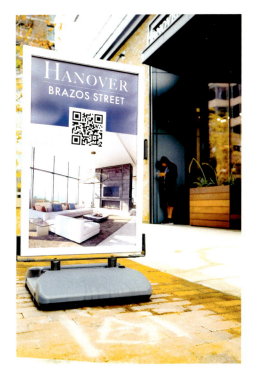

Austin, Texas

New Skyline

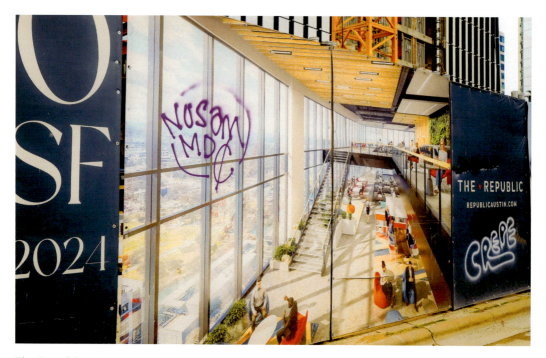

The Republic

The New Money

Right: Just Arrived

Below: Your New Home

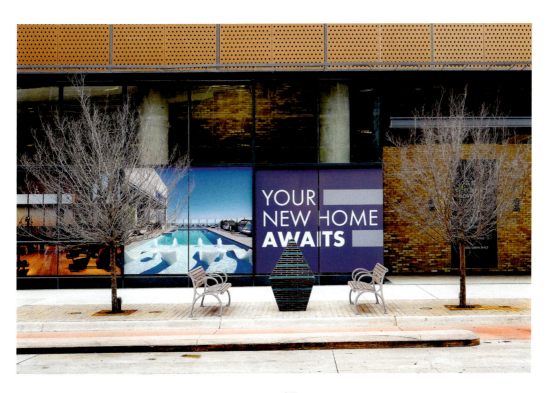

7
Broken Dreams

When people arrive in Austin, they have all heard about living the big life, the huge music festivals, the arts and culture, and the mouthwatering BBQ. There is no doubt about it, the vibe and lifestyle energy in Austin is one that draws in a multitude of dreamers to move or visit here. There are those dreamers that come here with grand visions of a fresh start in life, whether it's affordable housing, warmer climates, or just a complete change of scenery. However, sometimes your big city dreams just don't work out.

When I am out walking around the city streets with my camera, I have noticed the ebb and flow of the homeless population. It is, at times, a stark contrast: there are times when they are "everywhere," and other times, in very small, scattered numbers. There will be months when you are walking down Congress Ave., and on almost every block, there are several people sleeping on the city benches. I have also seen it to the point where there are small groups gathered in front of the benches, hanging out for the day.

A few years back, when I would be out for night photography, the early morning streets would resemble a scene from *The Walking Dead*. There would be people up and down the sidewalks, at the storefronts, and in the middle of the streets. I often wonder what their original goal was when arriving in the city.

Many newcomers who arrive here are quite taken back by the cost of living in Austin, and quickly find out how expensive the city really is. With the influx of thousands of people moving into the city, there are many who find the money they have saved up will not be sufficient. I often talk to homeless individuals while I am out on my photo walks, and their stories are as diverse as the individuals themselves. Contrary to common stereotypes, most of their circumstances are not related to drug use. Most of the people I talk to ended up in this position due to unforeseen and unfortunate life events, such as a death in the family, divorce, or just a sudden twist of life's fate.

For these individuals, living in the "Live Music Capital of the World" is not so entertaining. Yet the city has not turned a blind eye to the issue. Some very creative solutions have been created to address the problem, such as the Community First Village, a place where homeless individuals can have a safe place to live and become part, once again, of the city's lifeline. Then there are some businesses that do not survive. Each year, there are thousands of businesses that open in the state and several that fade

Broken Dreams

away. In a city where all that glitters looks like gold, some businesses collide with the unpredictability of the ATX life.

Those dreams can unexpectedly come crashing down, resulting in boarded-up windows. Just because you build it doesn't mean that they will come. The competition for business here in Austin is very competitive, and the margins are thin. The cycle will continue, and those boarded-up windows will be covered in graffiti art by an artistic visionary, the realization of another individual's dream. Austin is full of electric energy and that "Come and Take it" attitude, but in the cold and harsh shadow of reality, this city of grand dreams, for some, turns out to be nothing but broken dreams.

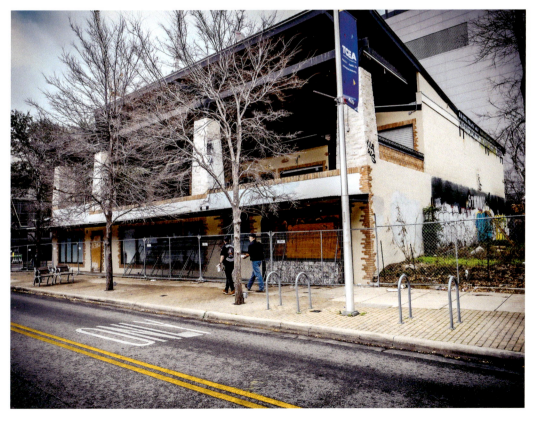

Boom and Bust

Austin, Texas

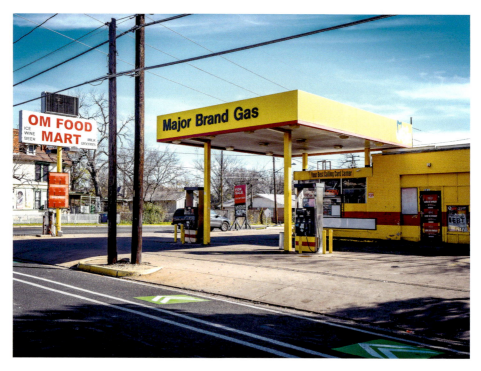

Cheap Gas

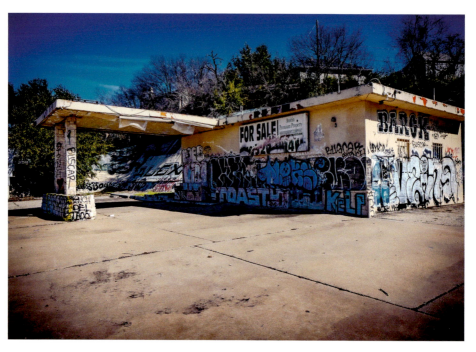

Still for Sale

Broken Dreams

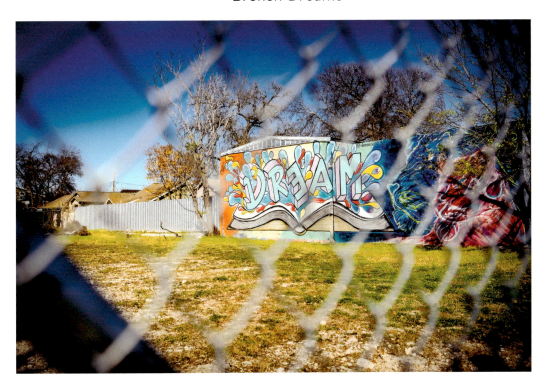

Above: Fenced-Off Dreams

Right: Long Way Home

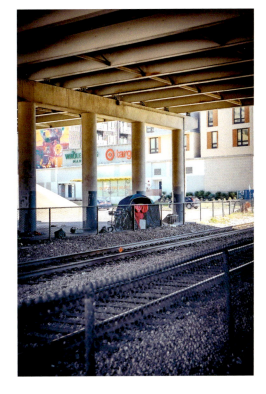

Austin, Texas

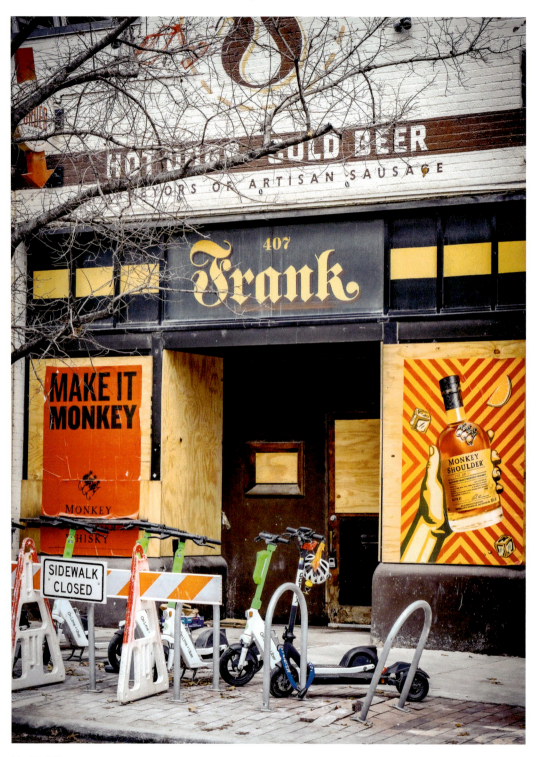

No Hot Dogs

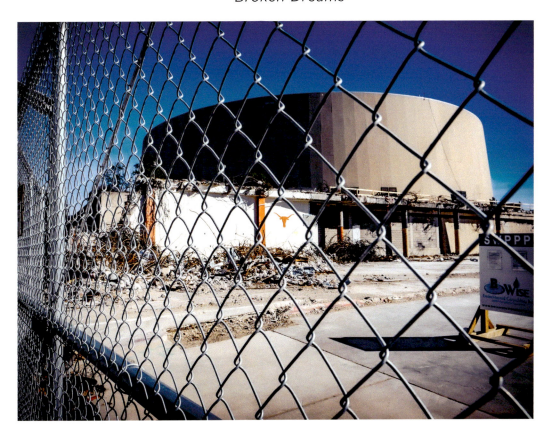

Above: The Good Old Days

Right: No Vacancy

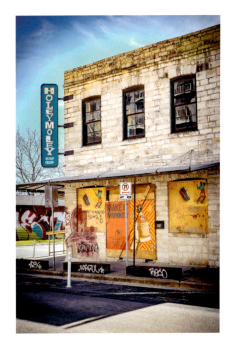

Final Thoughts

If you one day get the chance to come and visit Austin, Texas, I suggest staying for at least a couple of days. You will get the chance to see and experience ever-changing scenery and catch a case of "Texas fever." There are so many places to see and things to do while you are here. While the "live music" is what makes Austin unique among most U.S. cities, the music aspect of it is a drop in the bucket of what this city has to offer you. I have been photographing this city for the past several years, and as it continues to change its landscape, I, too, have changed and grown in the way I "see" the city from the angle of my viewfinder as I look for new shapes, characters, and colors. From its shopping districts, the vast amount of creative art, and excellent food, it's a cultural mecca. Let's not forget the "Keep It Weird' mentally of the people here; no doubt ATX has its own vibe.

I hope the pictures in this book will encourage you to come and visit for a while. When you do come, bring a water bottle, your best walking shoes, and an empty stomach; you will have a good time. Like I always tell people that I meet: Stay Creative, My Friends.

Bibliography

Austintexs.gov/Carver_Museum_Exhibits (2024)

Brown, M. "Why Thousands of People are Moving to Austin, Texas," greenresidential.com/why-thousands-of-people-are-moving-to-austin-texas/

Buchele, M., "The origin of Austin as 'The Live Music Capital of the World,' take two," kut.org/austin/2019-03-12/the-origin-of-austin-as-the-live-music-capital-of-the-world-take-two

en.wikipedia.org /wiki/central_east_austin_austin_texas

en.wikipedia.org/wiki/George_Washington_Carver_Museum_and_Cultural_Center

en.wikipedid.org/ wiki/main_building_University_of_Texas_at_Austin

en.wikipedia.org/wiki/Pecan_Street_Festival

en.wikipedia.org/ wiki/south_by_southwest

en.wikipedia.org/wiki/south_congress

en.wikipedia.org /wiki/Stevie_Ray_Vaughan

en.wikipedia.org /wiki/Pennybacker_Bridge

Farrant, D., "28 Of The Greatest And Most Famous Musicians From Texas," hellomusictheory.com/learn/famous-musicians-from-texas/

Lee, D., "Where To Dine in East Austin: A Local's Guide to the Best Restaurants," feastio.com/best-east-austin-restaurants/

lostinaustin.org/Austin_festivals_2023

Marisa. K., "How Texas Shrank Its Homelessness Population — And What It Can Teach California," laist.com/news/housing-homelessness/how-texas-shrank-its-homelessness-population-and-what-it-can-teach-california

oldpecanstreetfestival.com

Phan, N., "ACL Music Festival Survival Guide," austintexas.org/austin-insider-blog/post/acl-survival-guide/

Thecontemporaryaustin.org/About_2024

Williams, G., "Art and the City: Austin Keeping Its Art Scene Weird, Unique and Wonderful," soundoflife.com/blogs/places/art-and-the-city-austin

About the Author

Edgar T. Mosley is a creative photographer based out of Austin, Texas. He has a passion for trying to capture those fleeting moments in life, not only on the streets of Austin, Texas, but also around the world. He has been capturing the people and cityscapes of this iconic city for the past decade. While serving in the military and traveling around the world, he has developed a deep desire to capture the very busy streets of various cities and the very ordinary beauty of life itself. You can always catch him on the streets of Austin practicing his craft, day or night. He loves to travel to cities both big and small, looking to improve his art. For more visual inspiration, you can see his work at www.moz89photography.com and visit his Instagram @ mozbooks89.